DATE DUE

TI SI YON				
ULU 58. 10				
SEP 18 WOV 19 '79				
18, &I mm				
EB 11 193				
10 34				

J743 A.ME

Ames, Lee J
Draw 50 airclanes, aircraft & Spacecraft X54843

BLIC LIBRARY

WATSEKA, IL INOIS

Draw 50 AIRPLANES, AIRCRAFT & SPACECRAFT

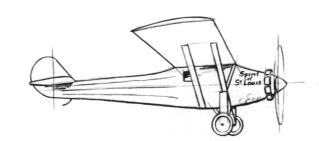

Draw 50

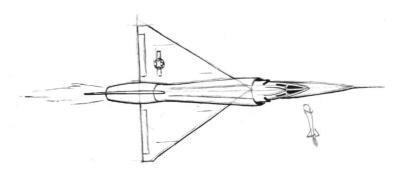

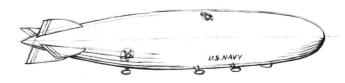

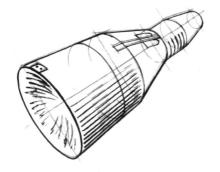

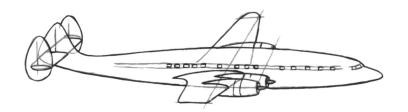

AIRPLANES, AIRCRAFT

Lee J. Ames

Doubleday & Company, Inc. Garden City, New York

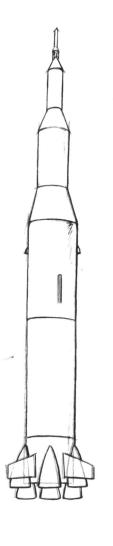

ISBN 0-385-12235-7 Trade
0-385-12236-5 Prebound
Library of Congress Catalog Card Number 76-51554
Copyright © 1977 by LEE J. AMES
All Rights Reserved
Printed in the United States of America
First Edition

J143 AMF

Much thanks to Holly Moylan for her considerable assistance.

To Aunt Sophie, who encouraged me at a ripe young age

25,247

To the Reader

This book will show you a way to draw airplanes, aircraft and spacecraft. You need not start with the first illustration. Choose whichever you wish. When you have decided, follow the step-by-step method shown. *Very lightly* and *carefully*, sketch out step number one. However, this step, which is the easiest, should be done *most carefully*. Step number two is added right to step number one, also lightly and also very carefully. Step number three is sketched right on top of numbers one and two. Continue this way to the last step. The last step, and the last step only, should be drawn in firmly.

It may seem strange to ask you to be extra careful when you are drawing what seem to be the easiest first steps, but this is most important because a careless mistake at the beginning may spoil the whole picture at the end. As you sketch out each step, watch the spaces between the lines, as well as the lines, and see that they are the same. After each step, you may want to lighten your work by pressing it with a kneaded eraser (available at art supply stores).

When you have finished, you may want to redo the final step in India ink with a fine brush or pen. When the ink is dry, use the kneaded eraser to clean off the pencil lines. The eraser will not affect the India ink.

Here are some suggestions: In the first few steps, even when all seems quite correct, you might do well to hold your work up to a mirror. Sometimes the mirror shows that you've twisted the drawing off to one side without being aware of it. At first you may find it difficult to draw the boxes, triangles or circles, or just to make the pencil go where you want it to. Don't be discouraged. The more you practice, the more you will develop control. The only equipment you'll need will be a medium or soft pencil, paper, the kneaded eraser and, if you wish, pen or brush and India ink—or a felt-tipped pen—for the final step.

The first steps in this book are shown darker than necessary so that they can be clearly seen. (Keep your work very light.)

Remember, there are many other ways and methods to make drawings. This book shows just one method. Why don't you seek out other ways to make drawings—from teachers, from libraries and, most importantly ...from inside yourself?

LEE J. AMES

To the Parent or Teacher

"David can draw a jet plane better than anybody else!" Such peer acclaim and encouragement generate incentive. Contemporary methods of art instruction (freedom of expression, experimentation, self-evaluation of competence and growth) provide a vigorous, fresh-air approach for which we must all be grateful.

New ideas need not, however, totally exclude the old. One such is the "follow me, step-by-step" approach. In my young learning days this method was so common, and frequently so exclusive, that the student became nothing more than a pantographic extension of the teacher. In those days it was excessively overworked.

This does not mean, however, that the young hand is never to be guided. Rather, specific guiding is fundamental. Step-by-step guiding that produces satisfactory results is valuable even when the means of accomplishment are not fully understood by the student.

The novice with a musical instrument is frequently taught to play simple melodies as quickly as possible, well before he learns the most elemental scratchings at the surface of music theory. The resultant self-satisfaction, pride in accomplishment, can be a significant means of providing motivation. And all from mimicking an instructor's "Do as I do."

Mimicry is prerequisite for developing creativity. We learn the use of our tools by mimicry. Then we can use those tools for creativity. To this end I would offer the

budding artist the opportunity to memorize or mimic (rote-like, if you wish) the making of "pictures." "Pictures" he has been anxious to be able to draw.

The use of this book should be available to anyone who wants to try another way of flapping his wings. Perhaps he will then get off the ground when his friend says, "David can draw a jet plane better than anybody else!"

LEE J. AMES

Draw 50 AIRPLANES, AIRCRAFT & SPACECRAFT

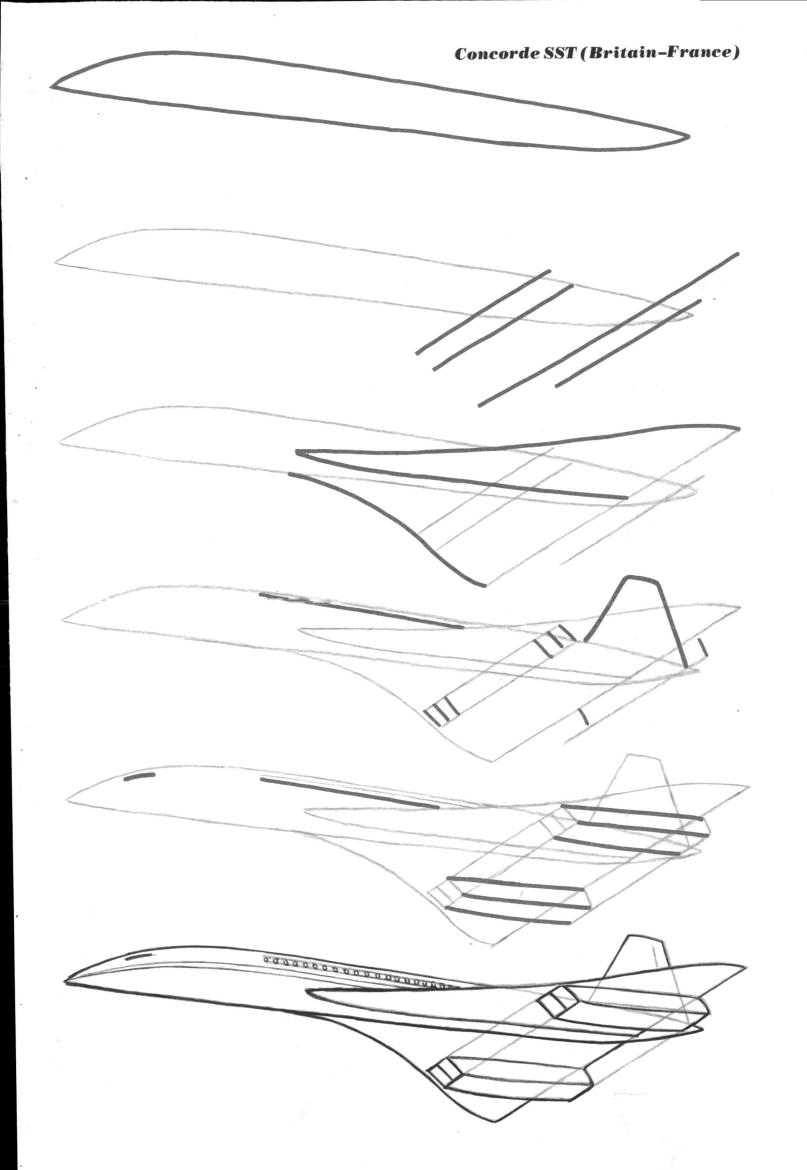

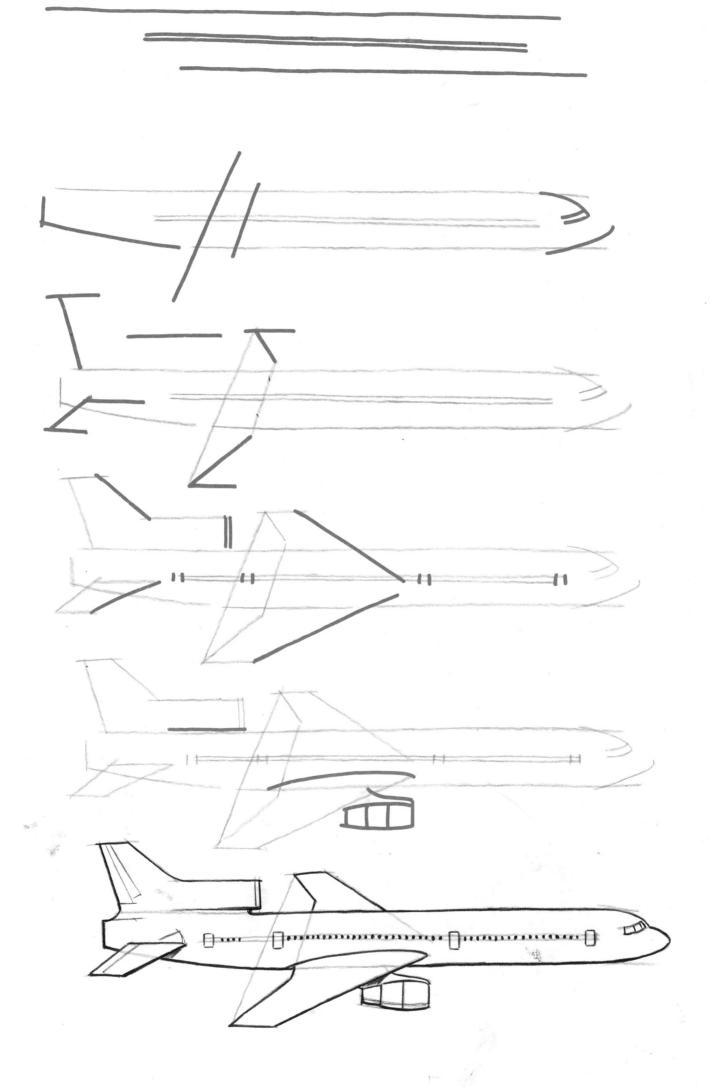

Boeing 727 (USA)

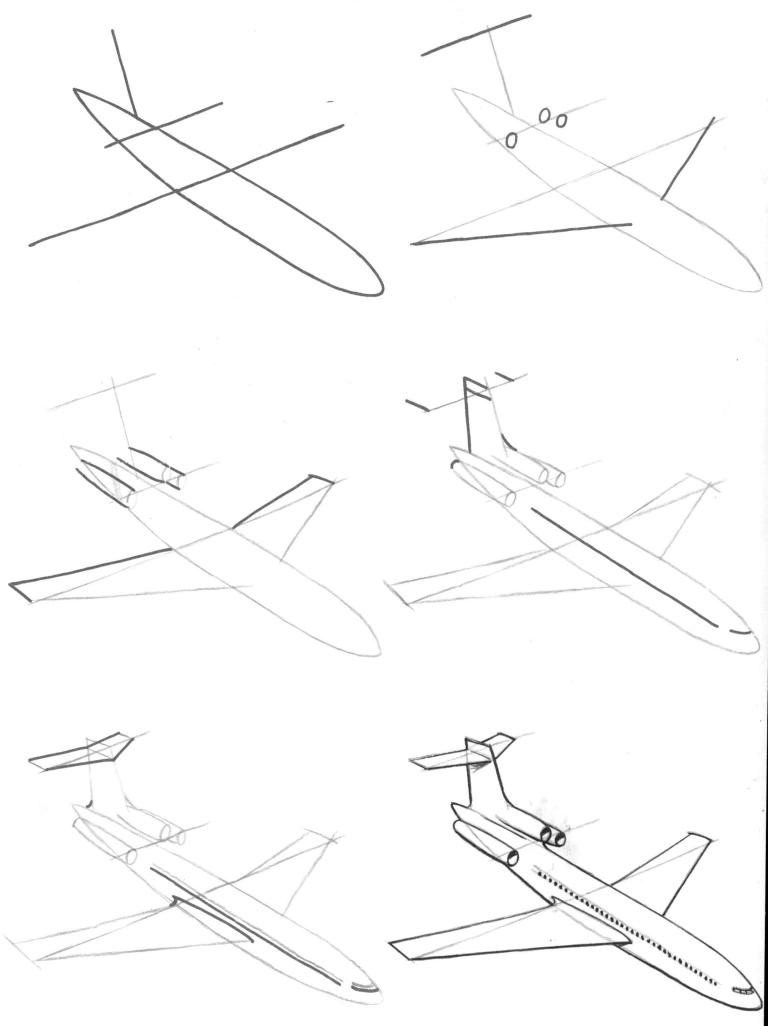

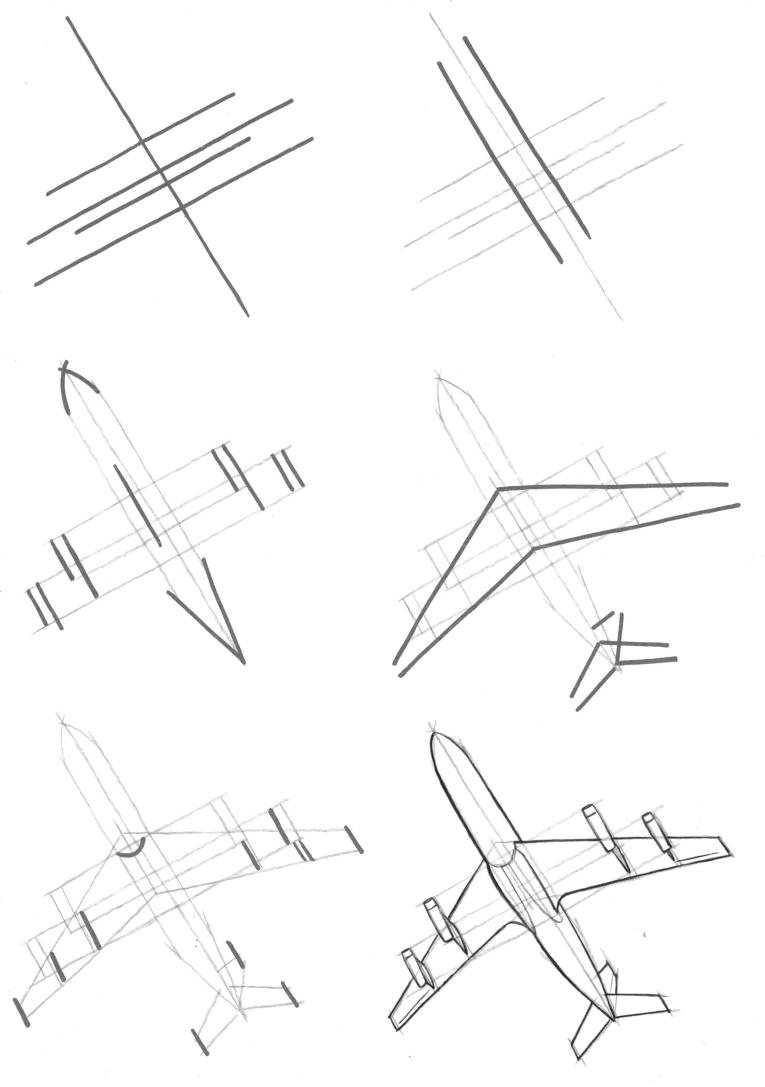

Lockheed Constellation (USA)

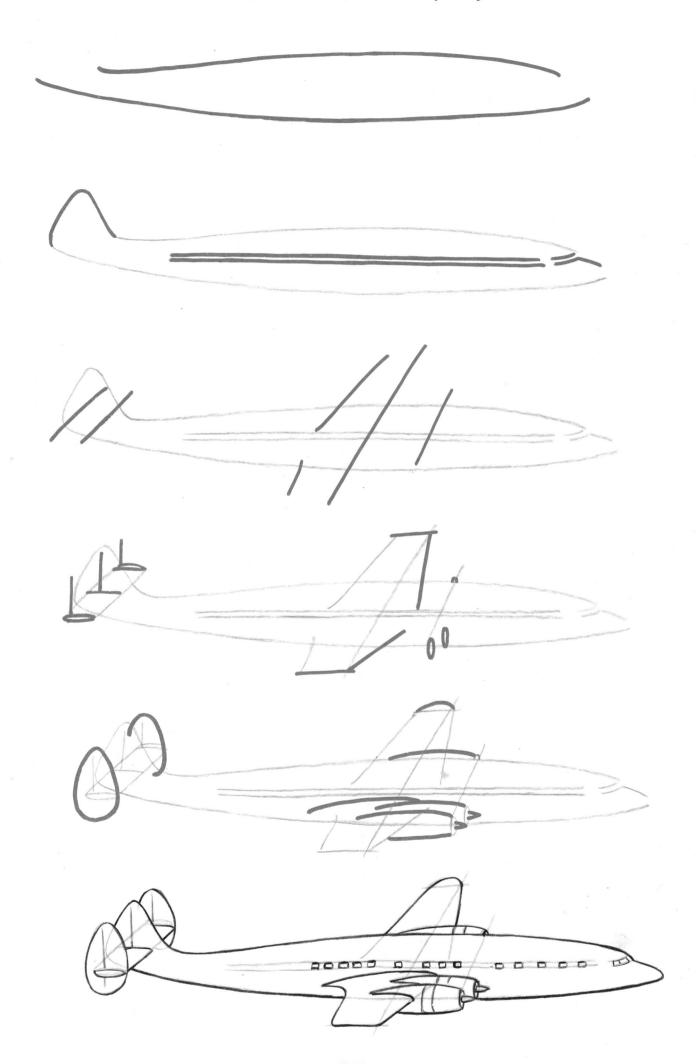

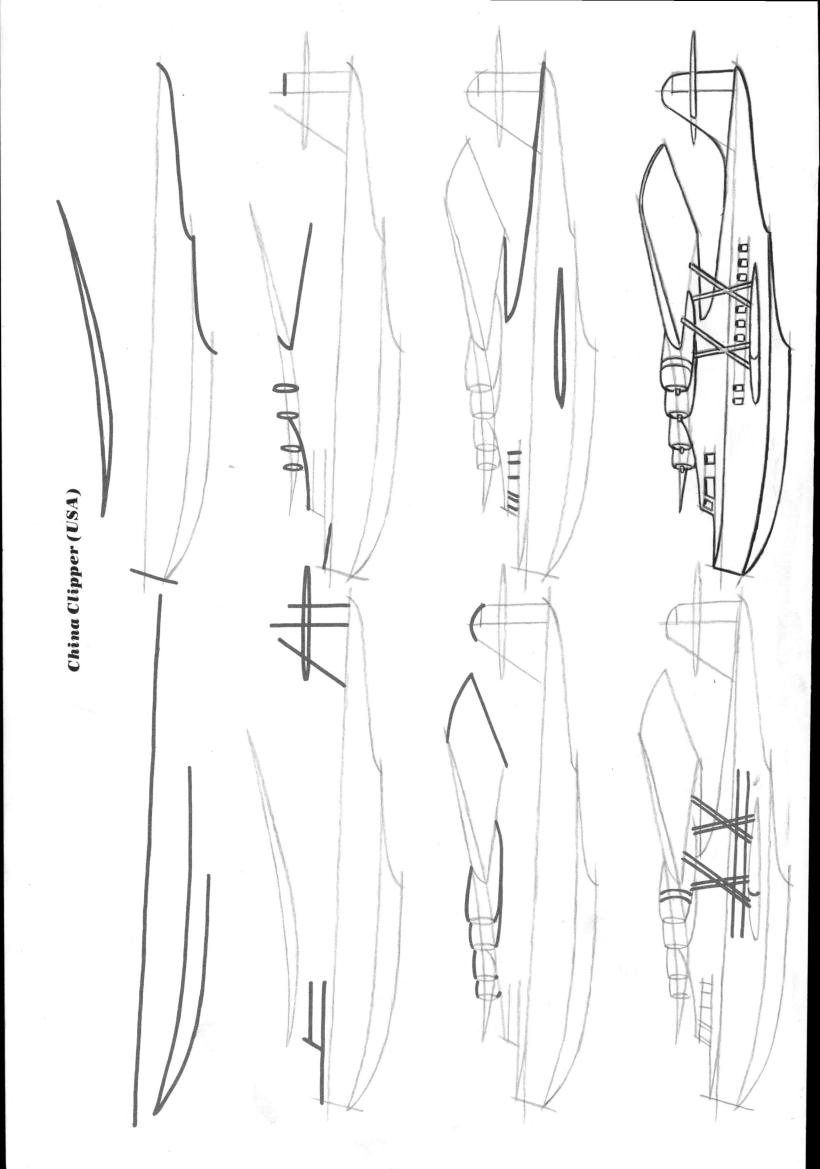

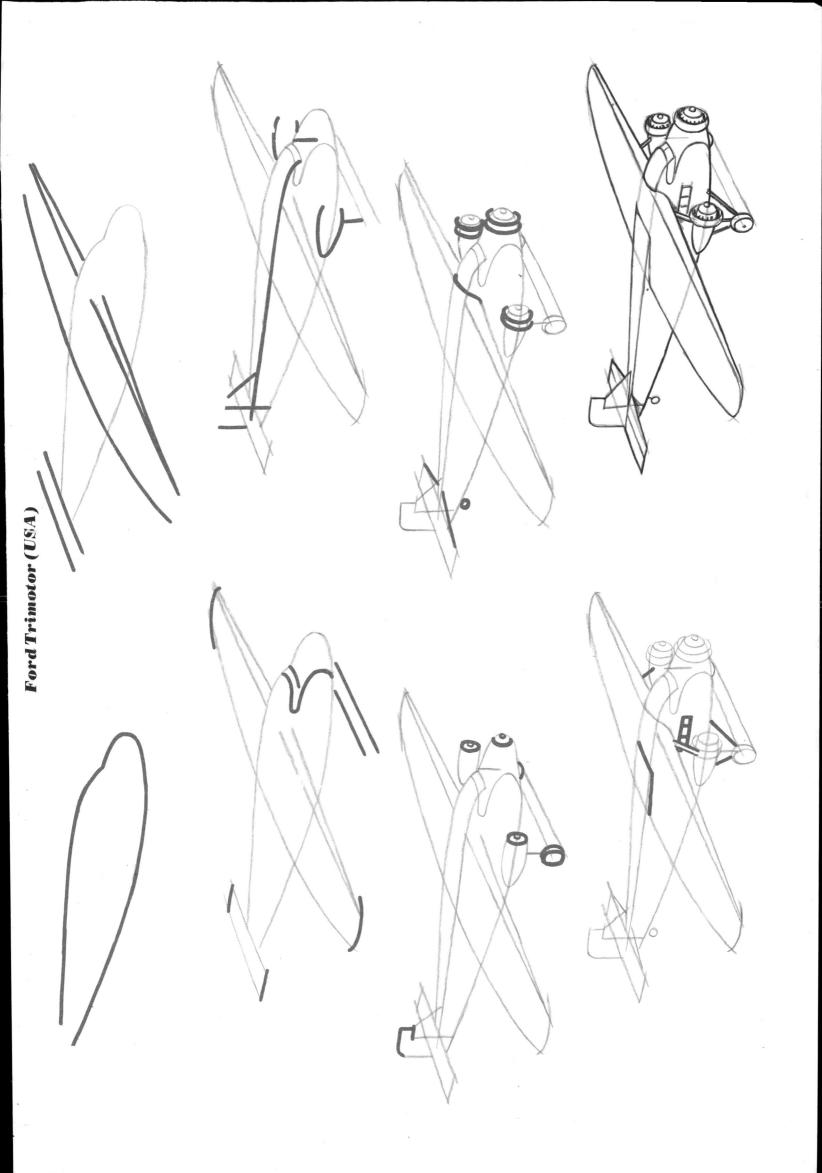

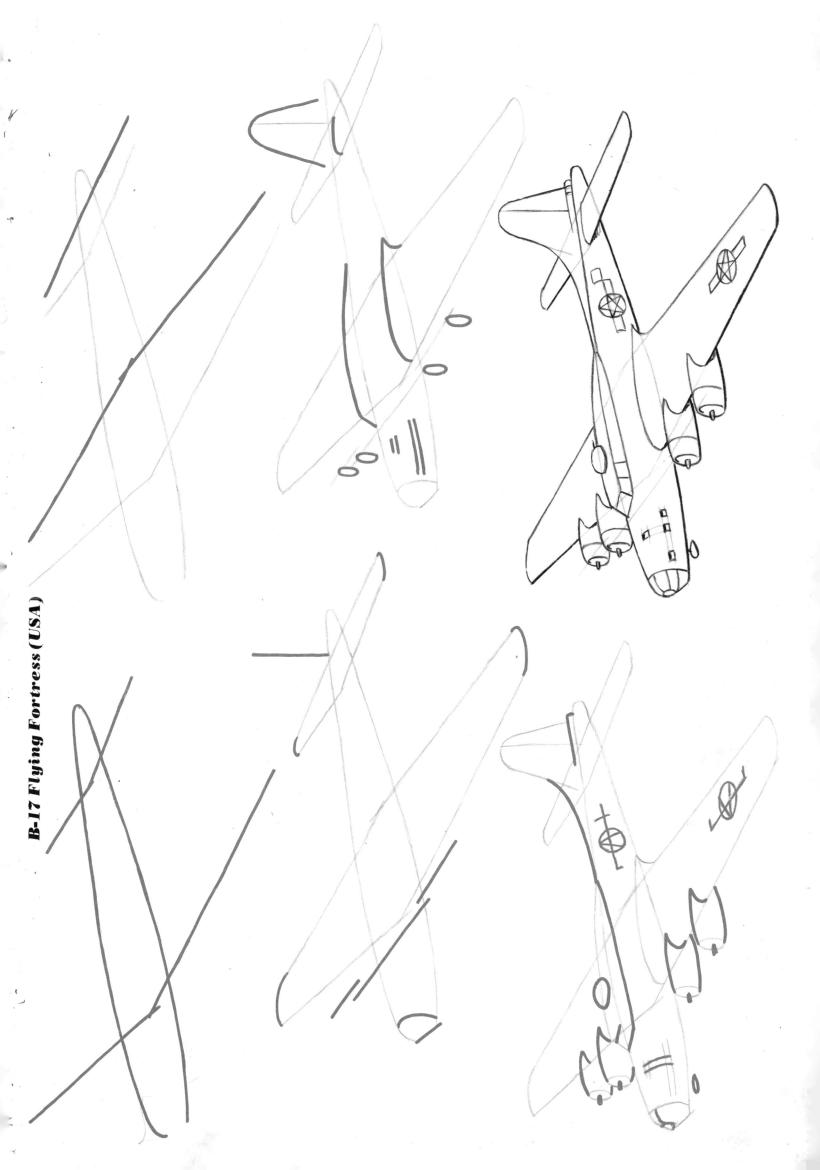

Beech C-45G (USA)

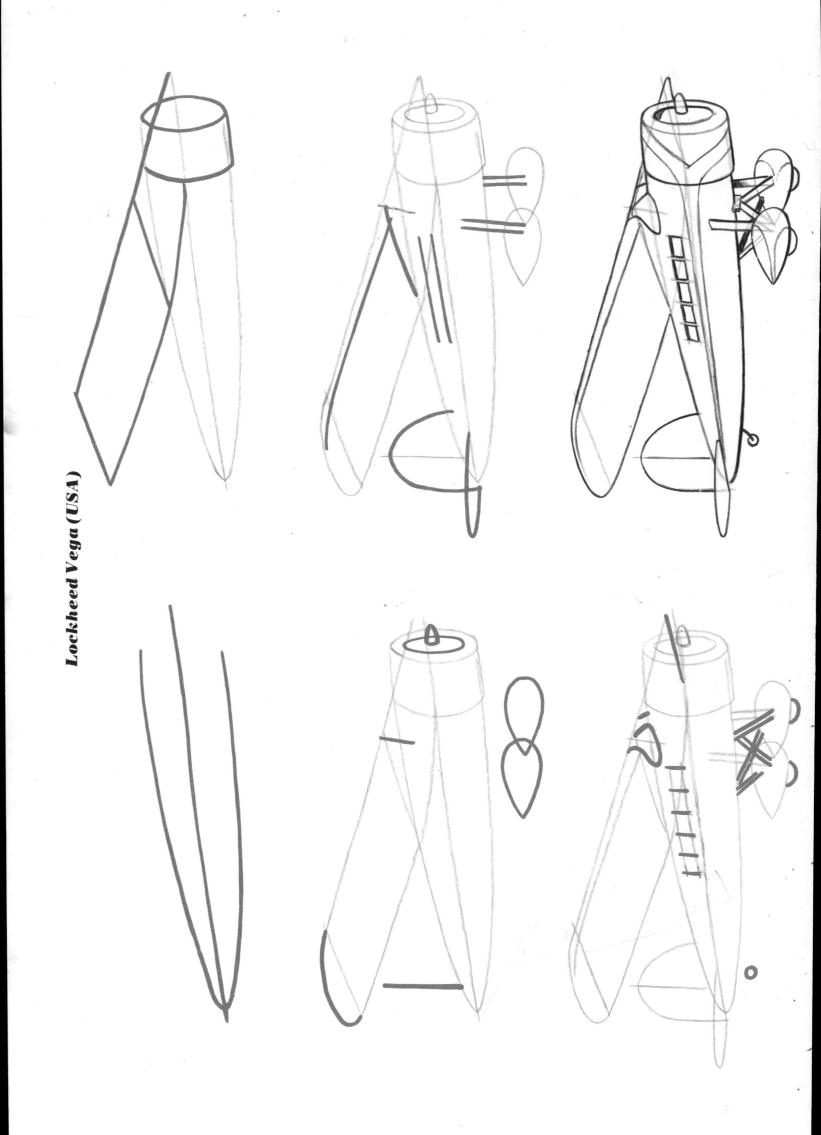

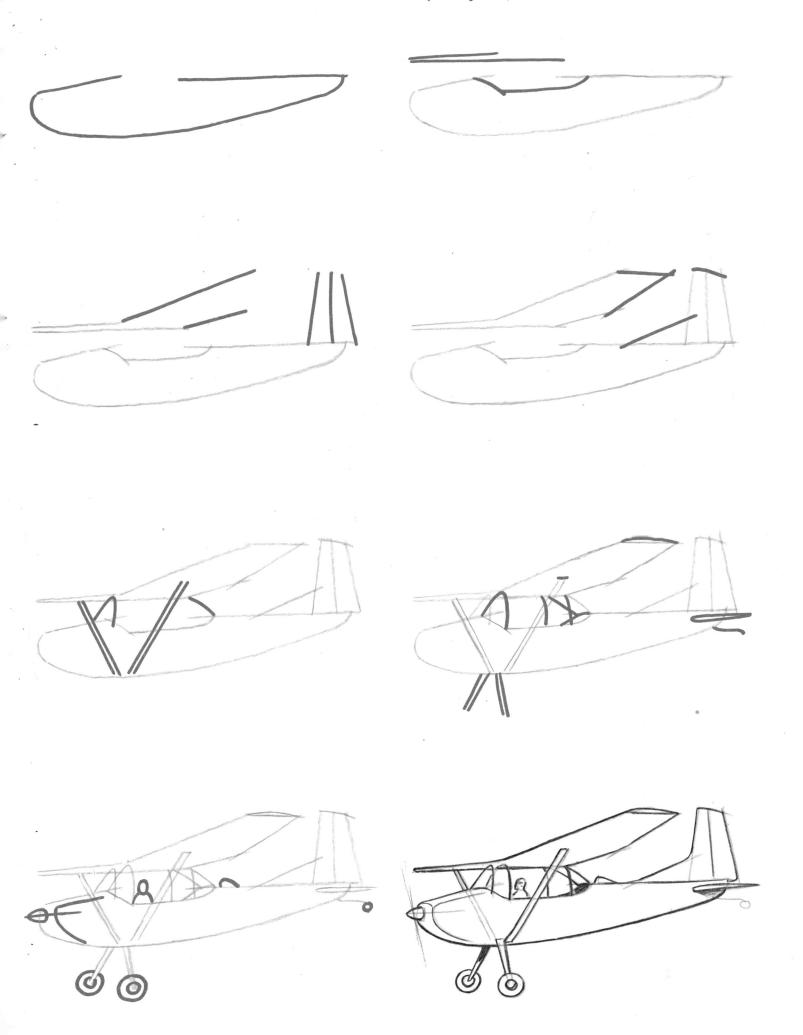

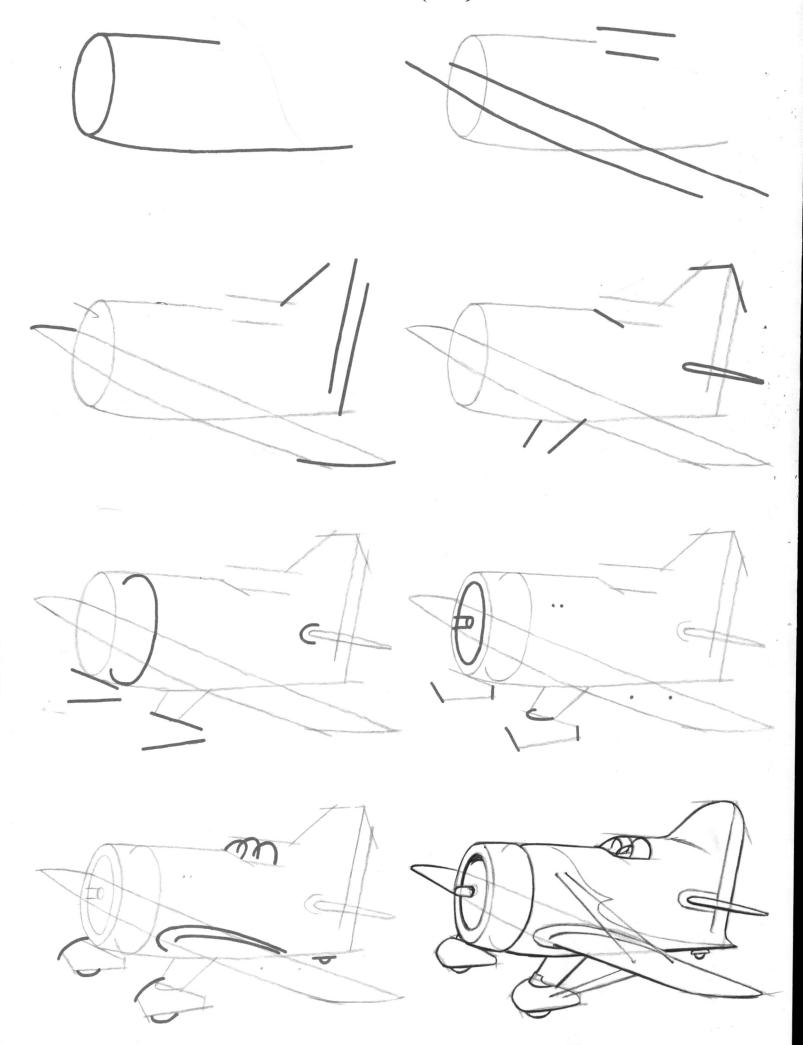

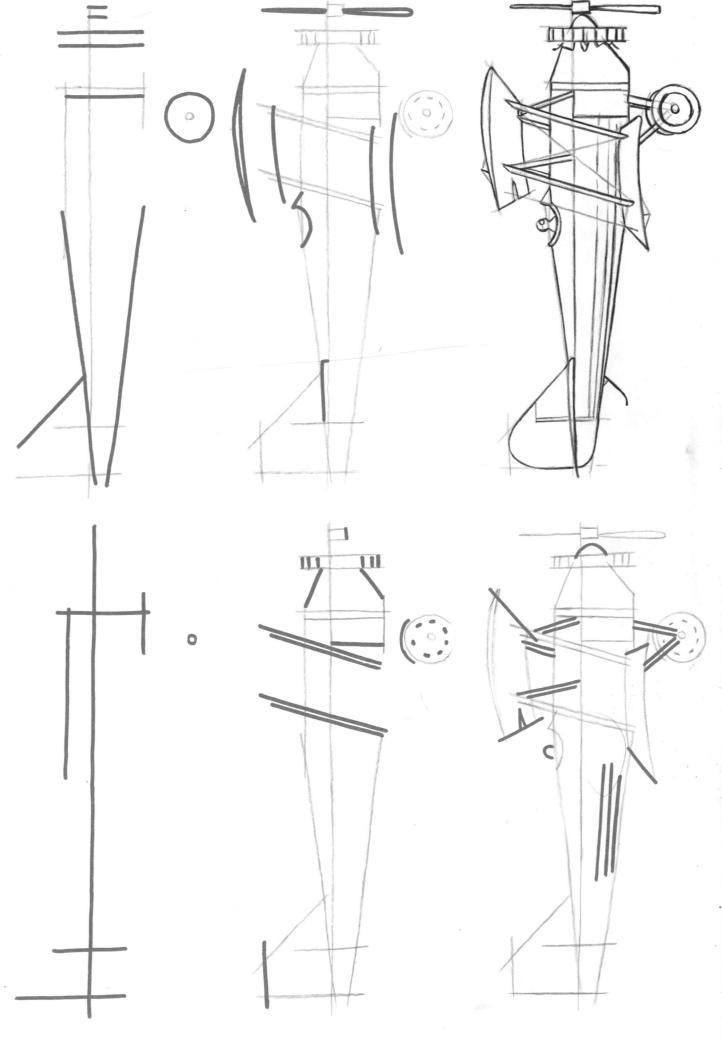

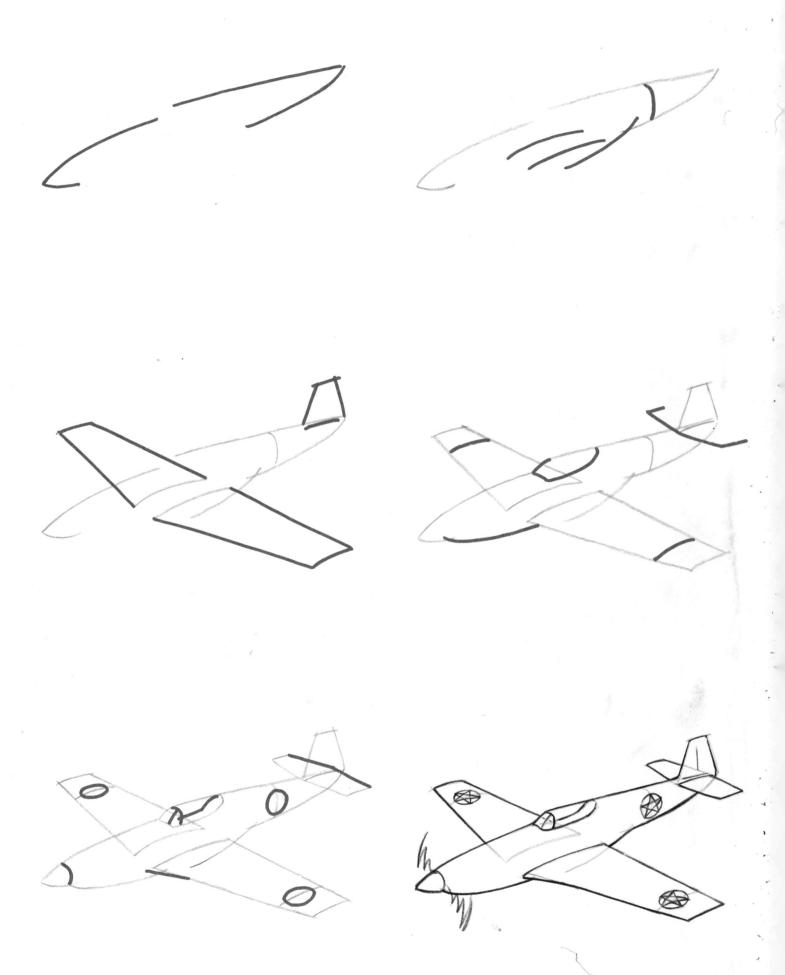

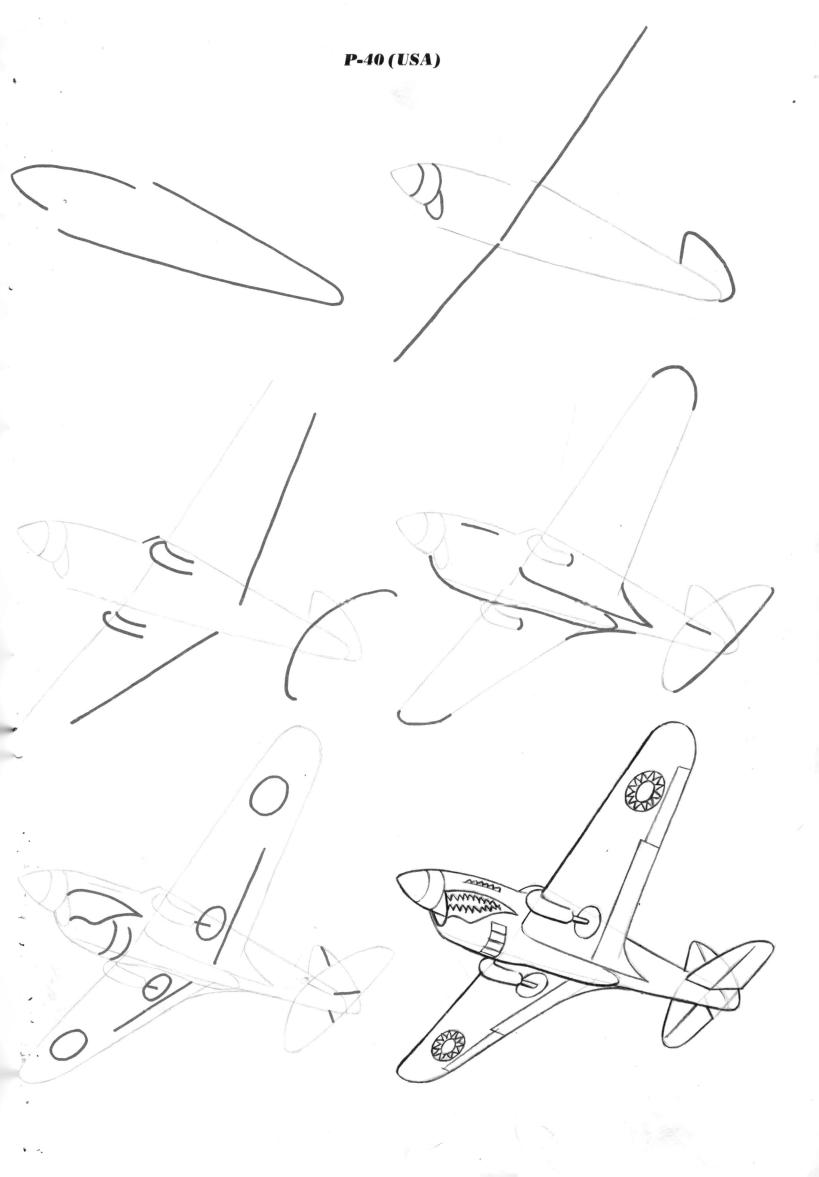

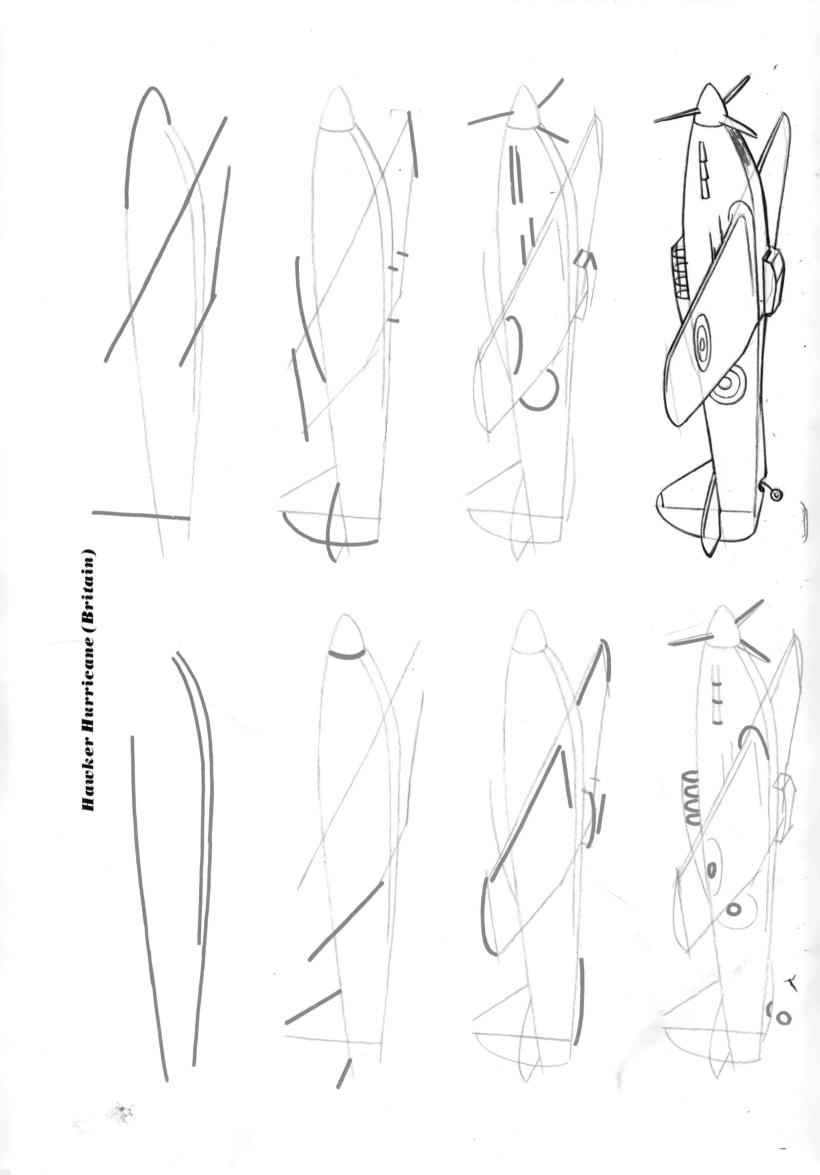

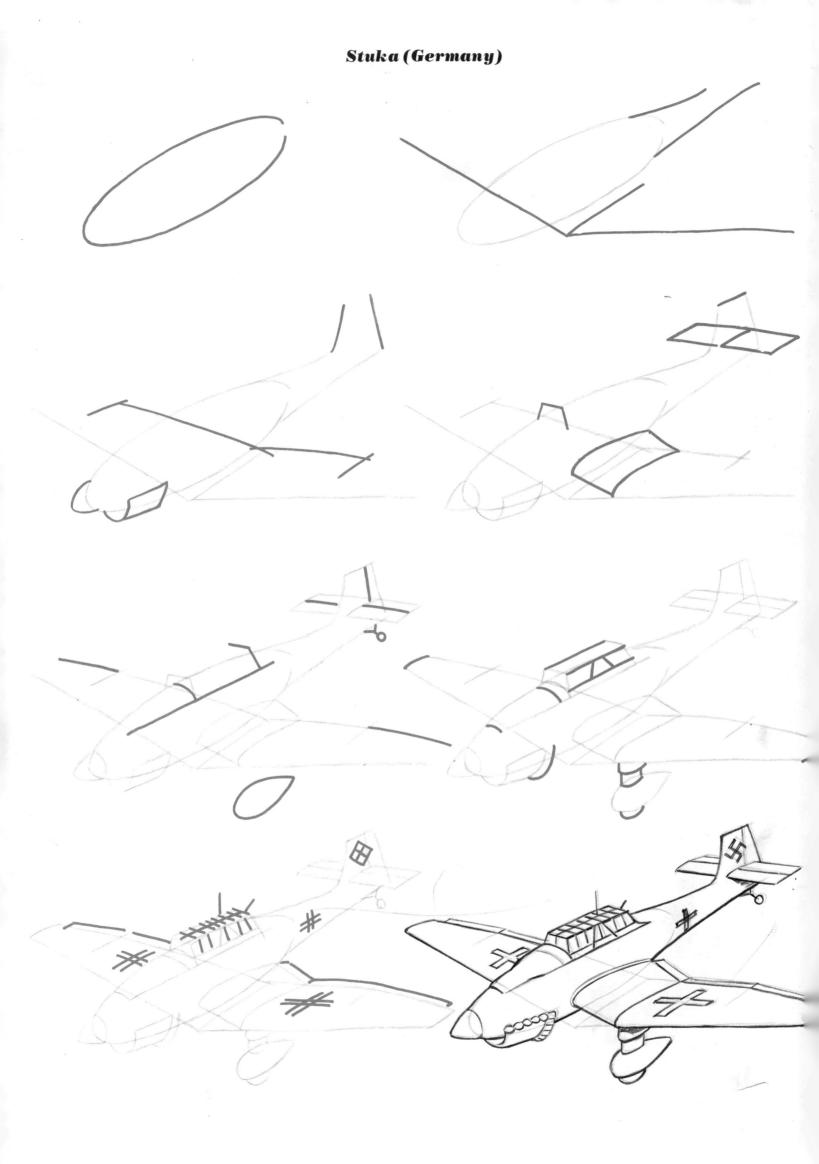

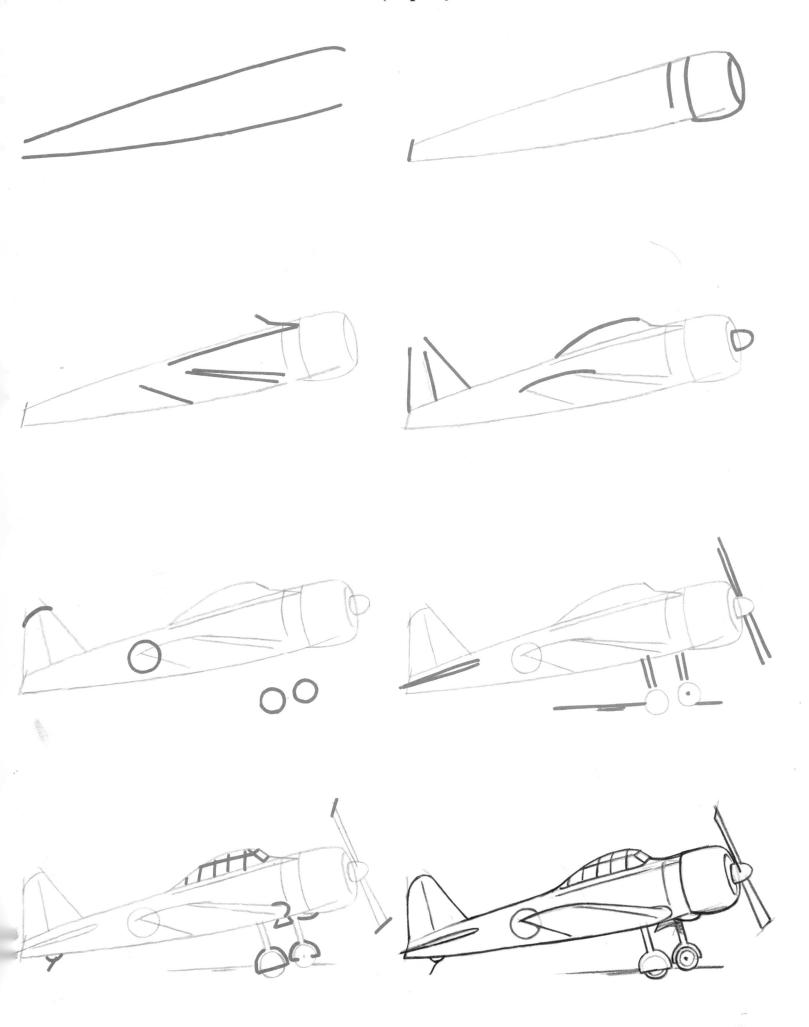

Grumman J2F-6 Duck (USA)

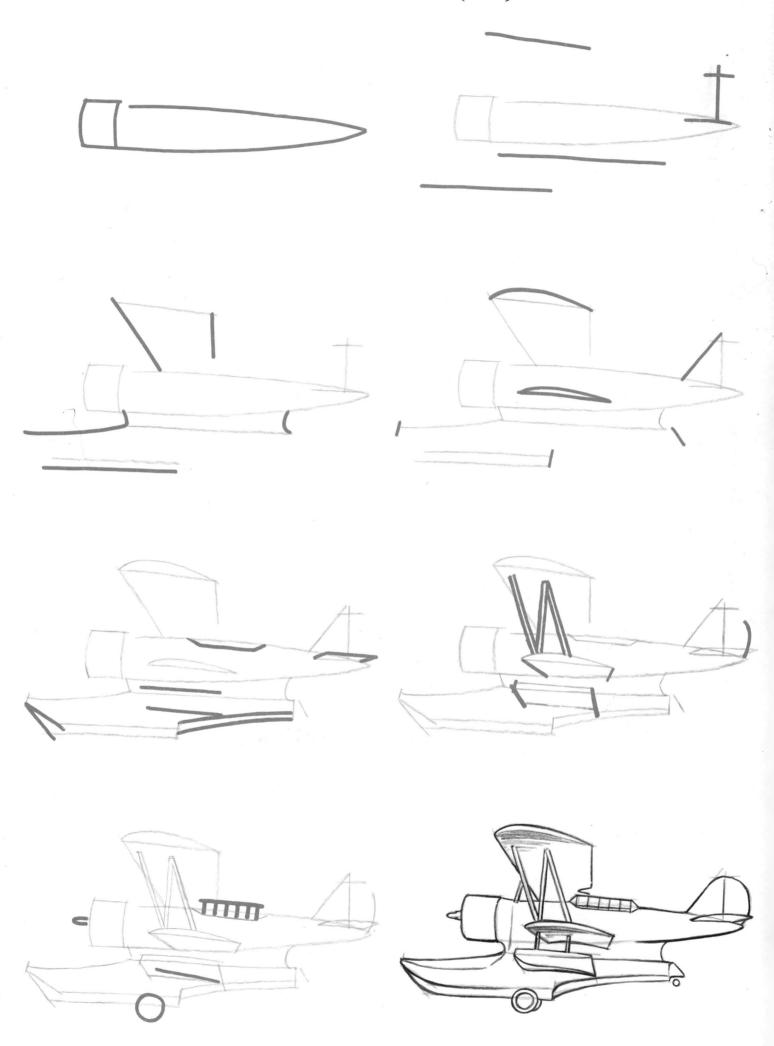

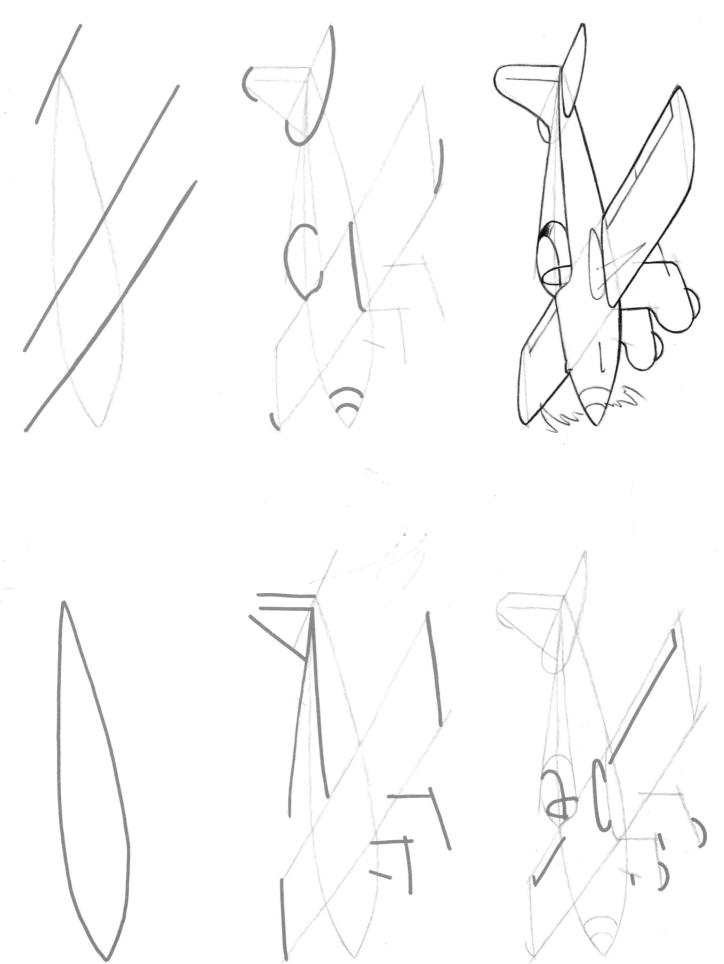

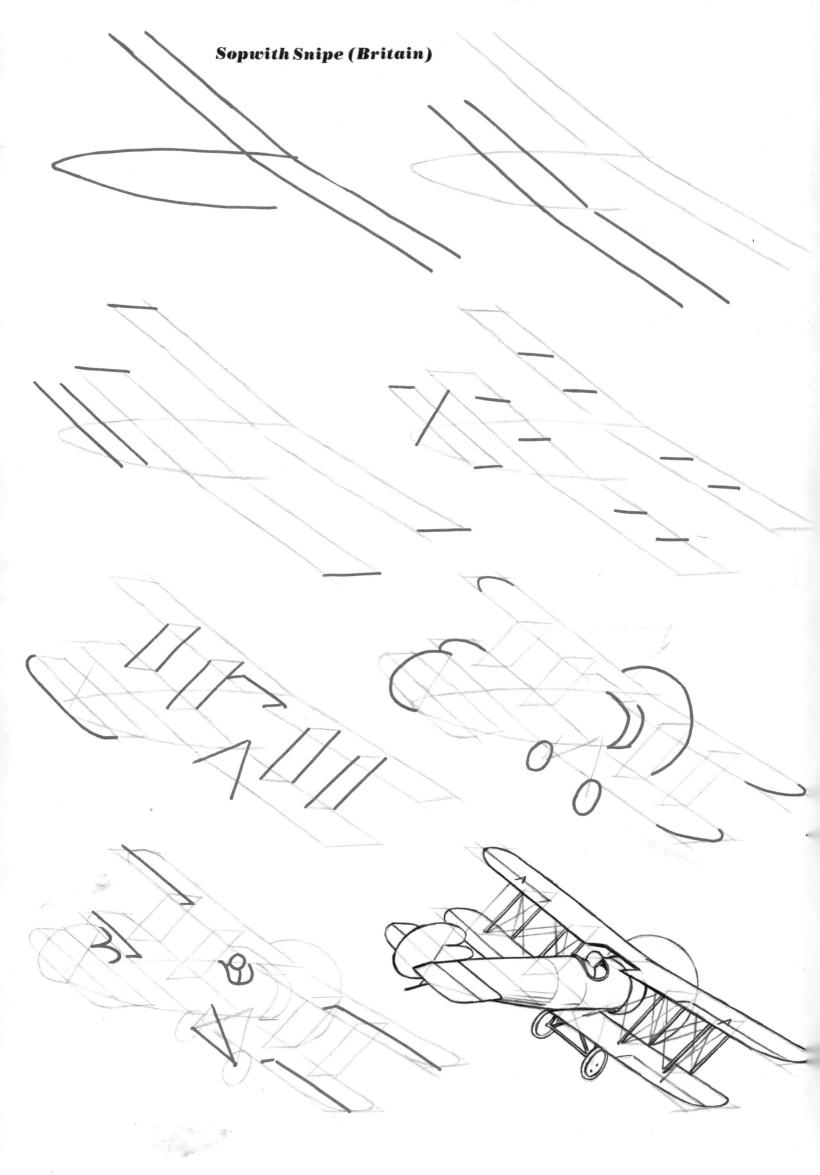

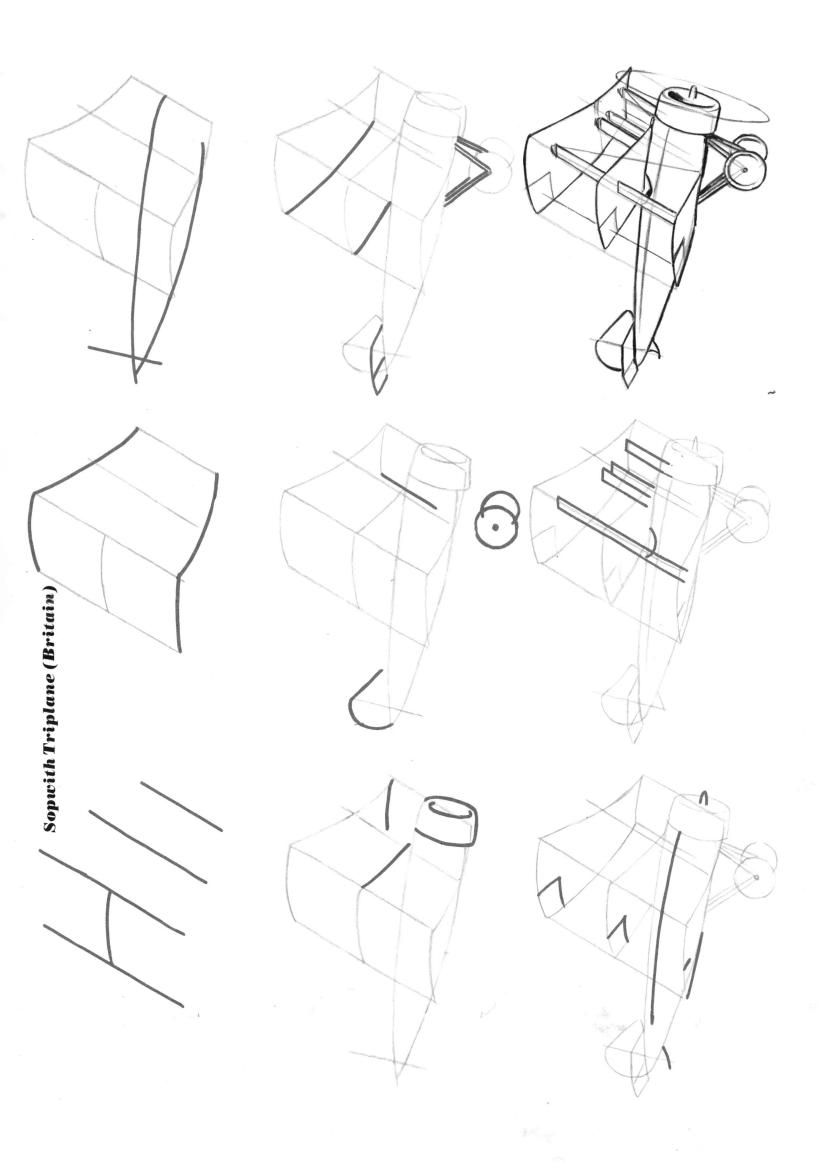

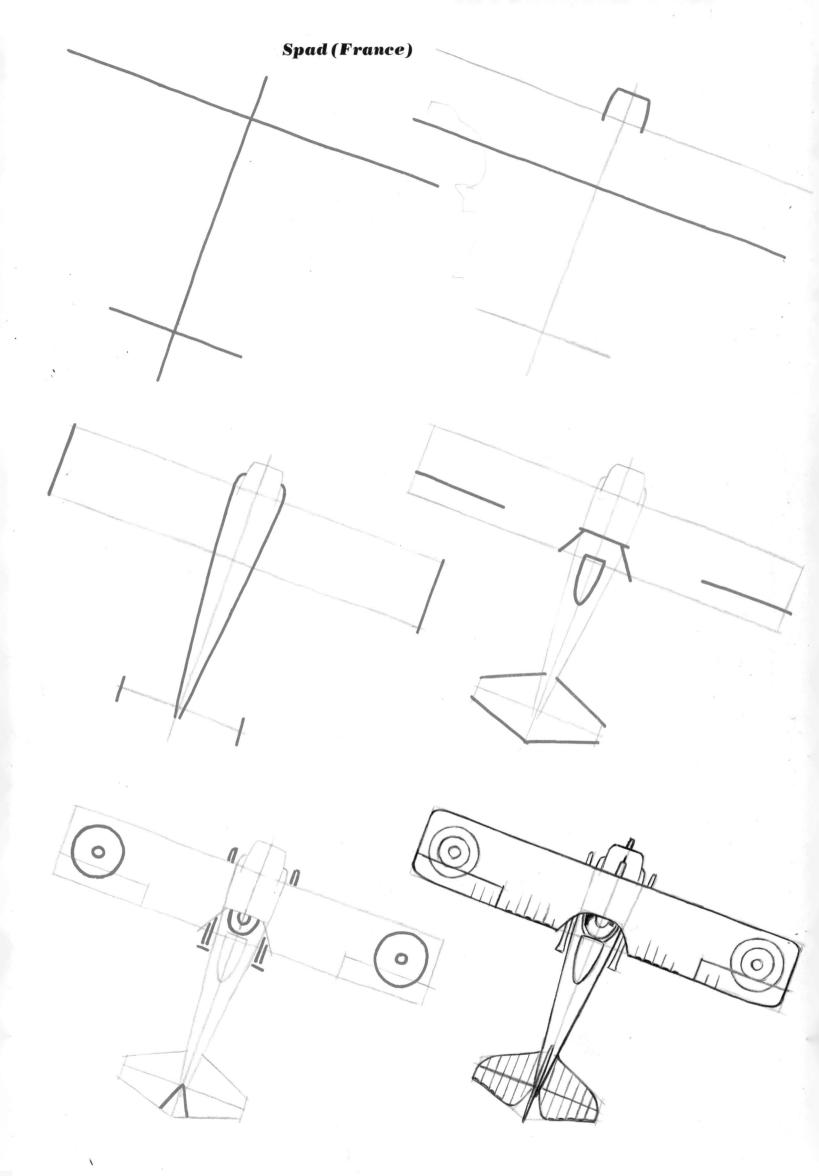

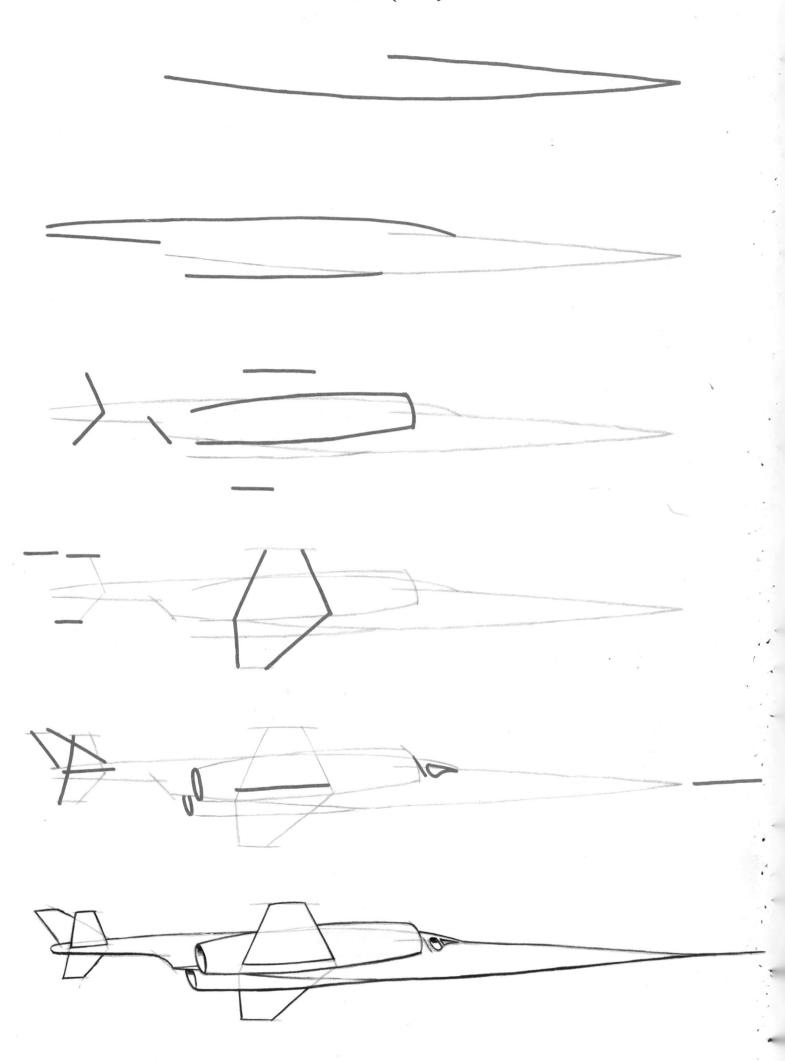

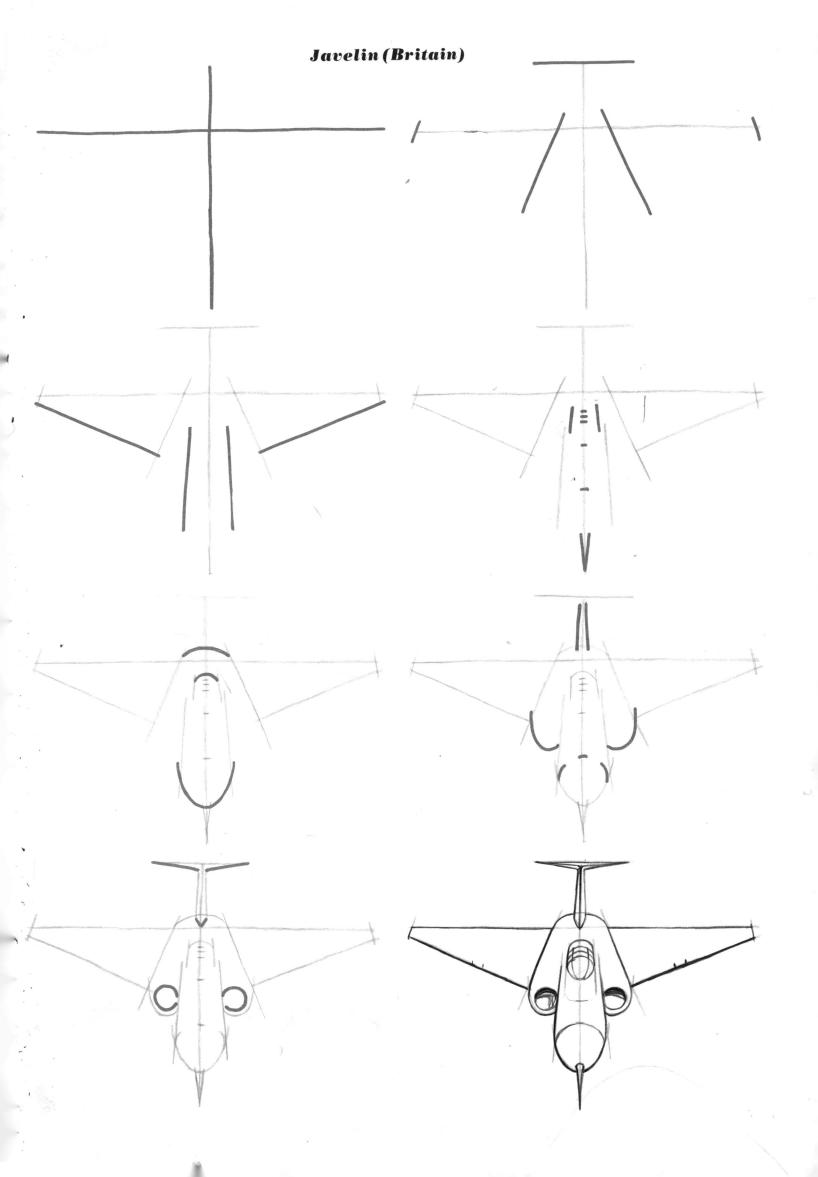

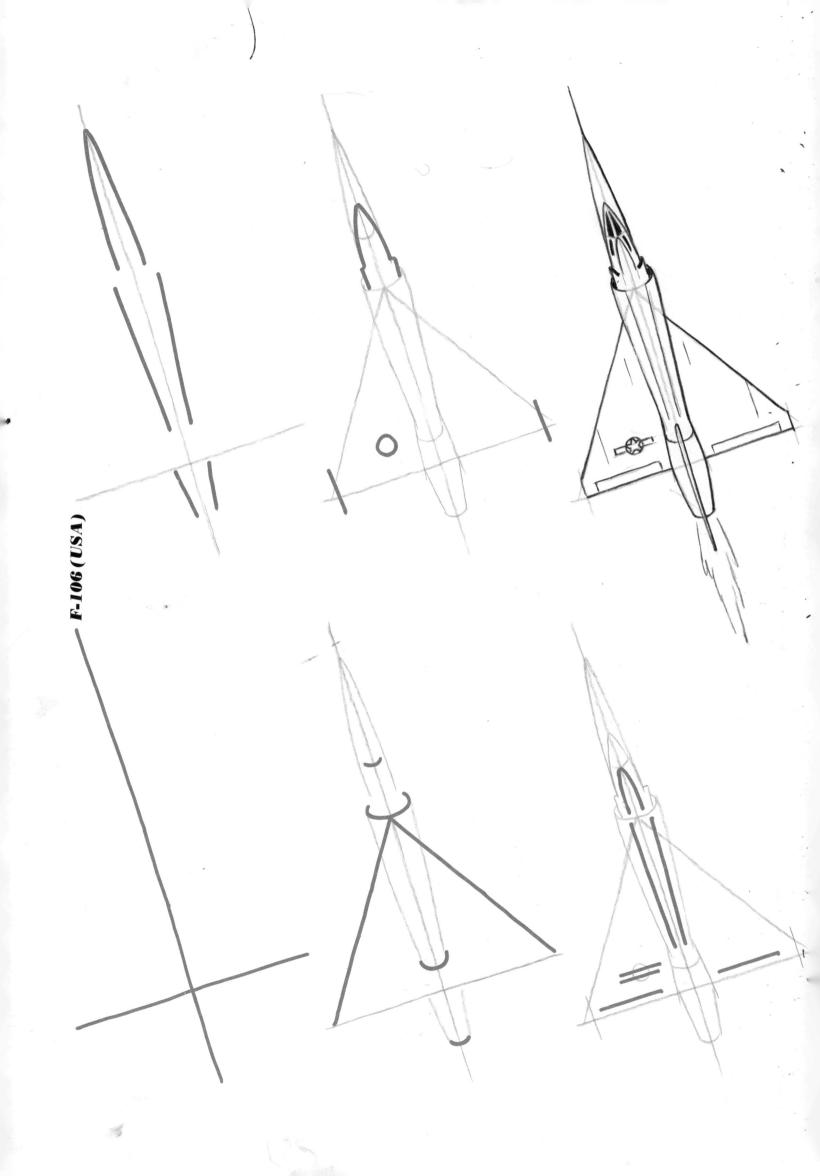

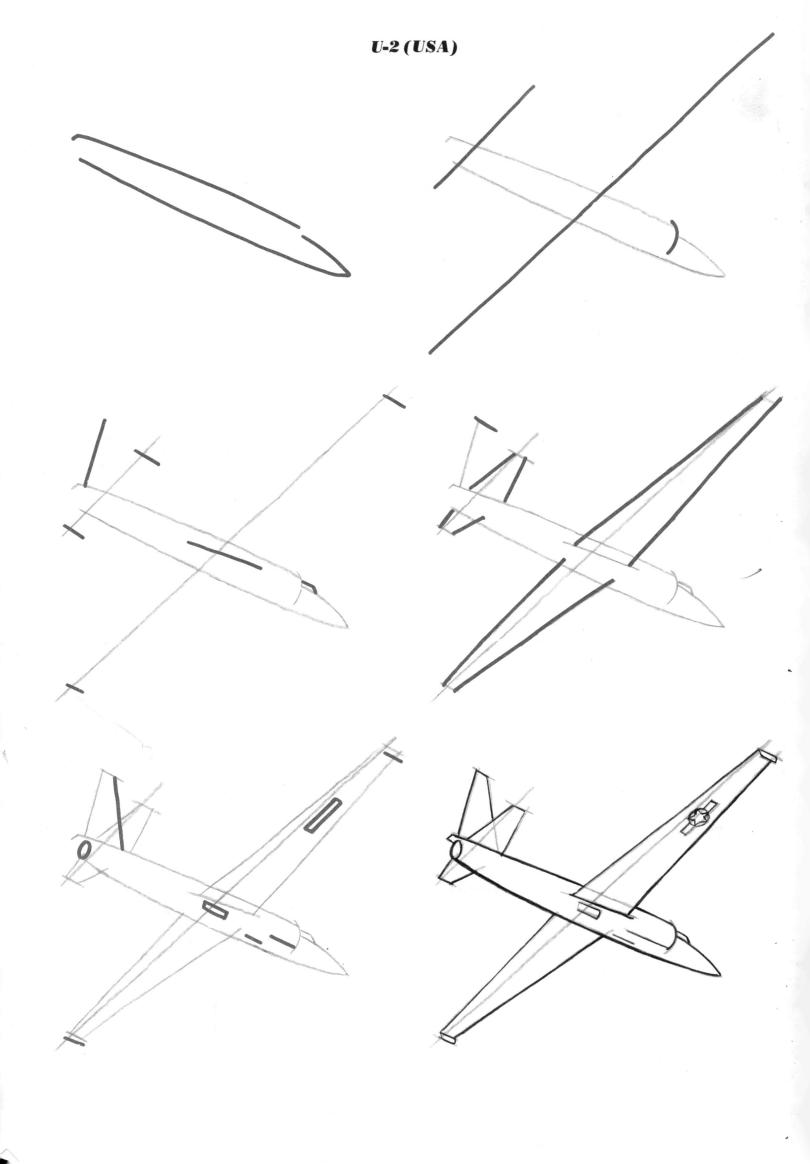

Lockheed F-94C Starfire (USA)

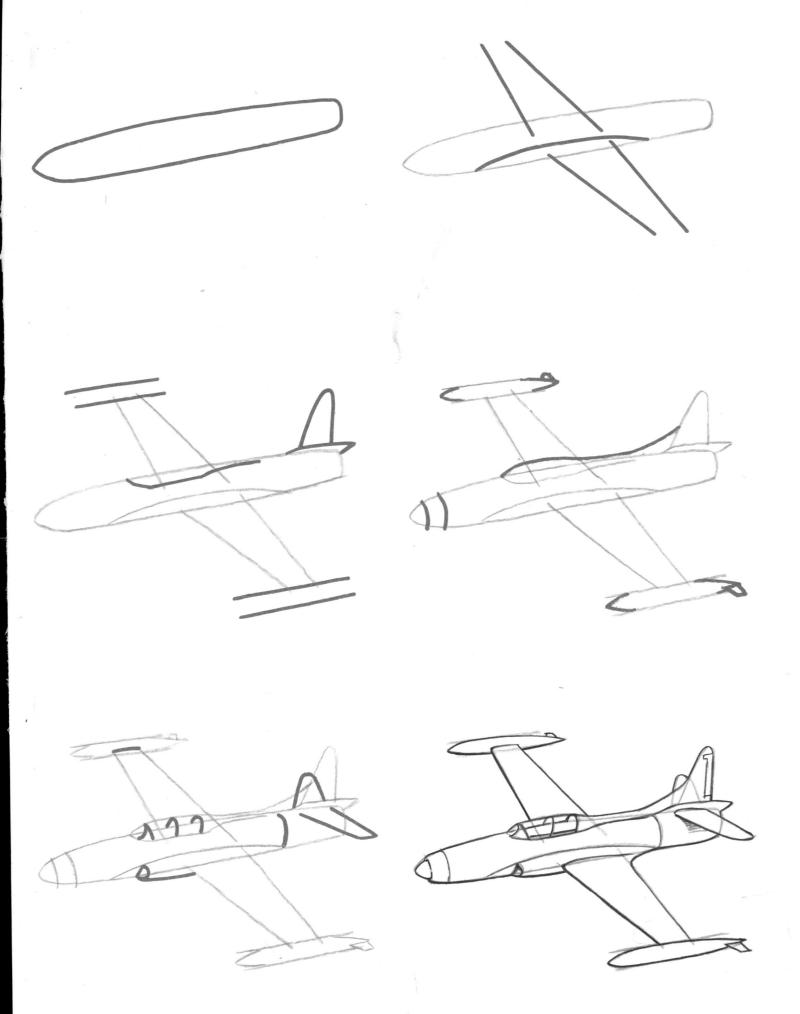

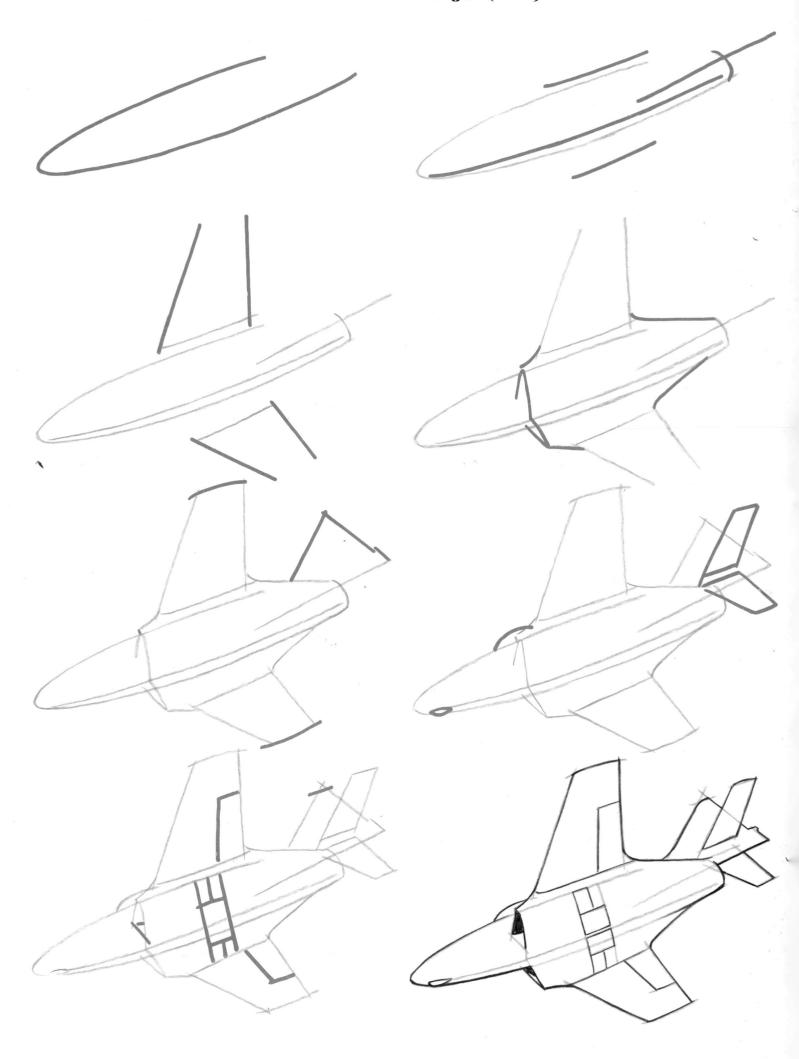

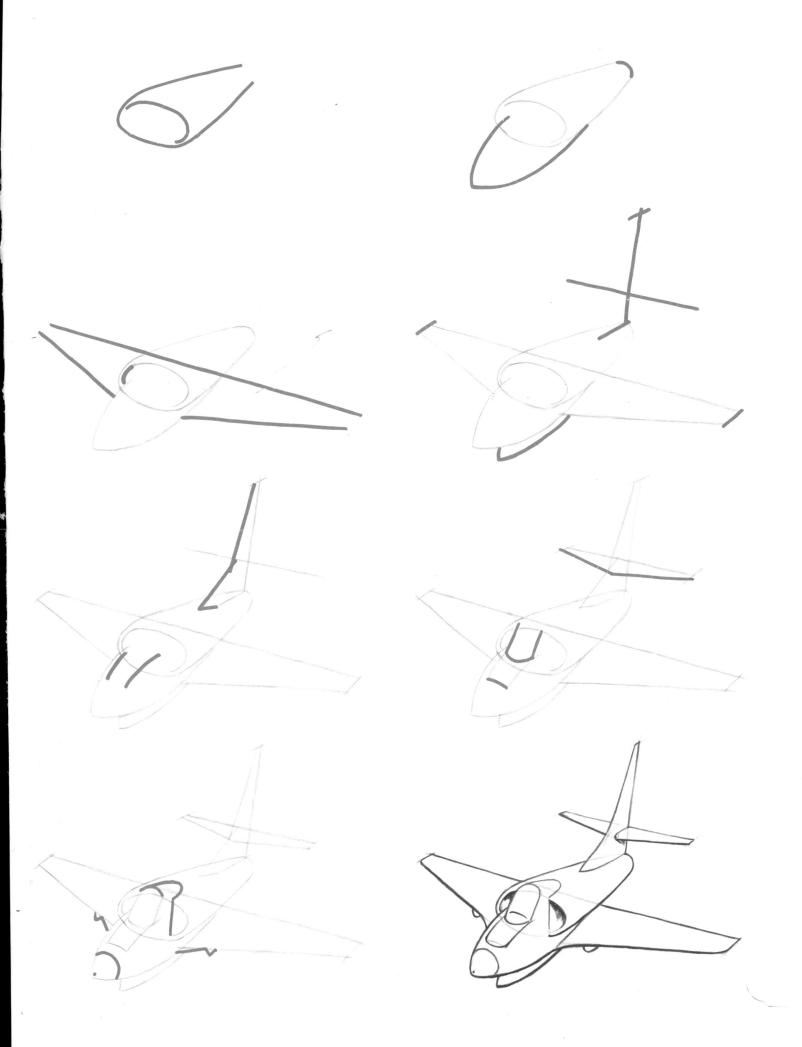

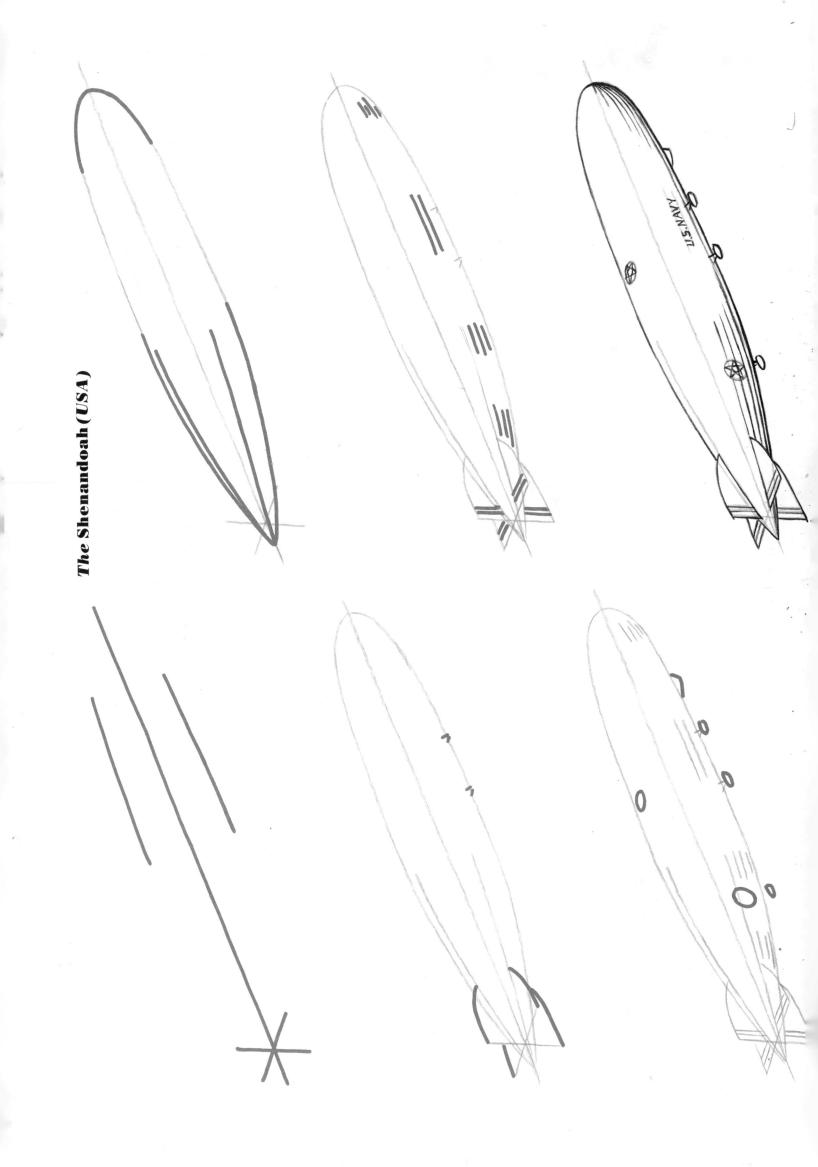

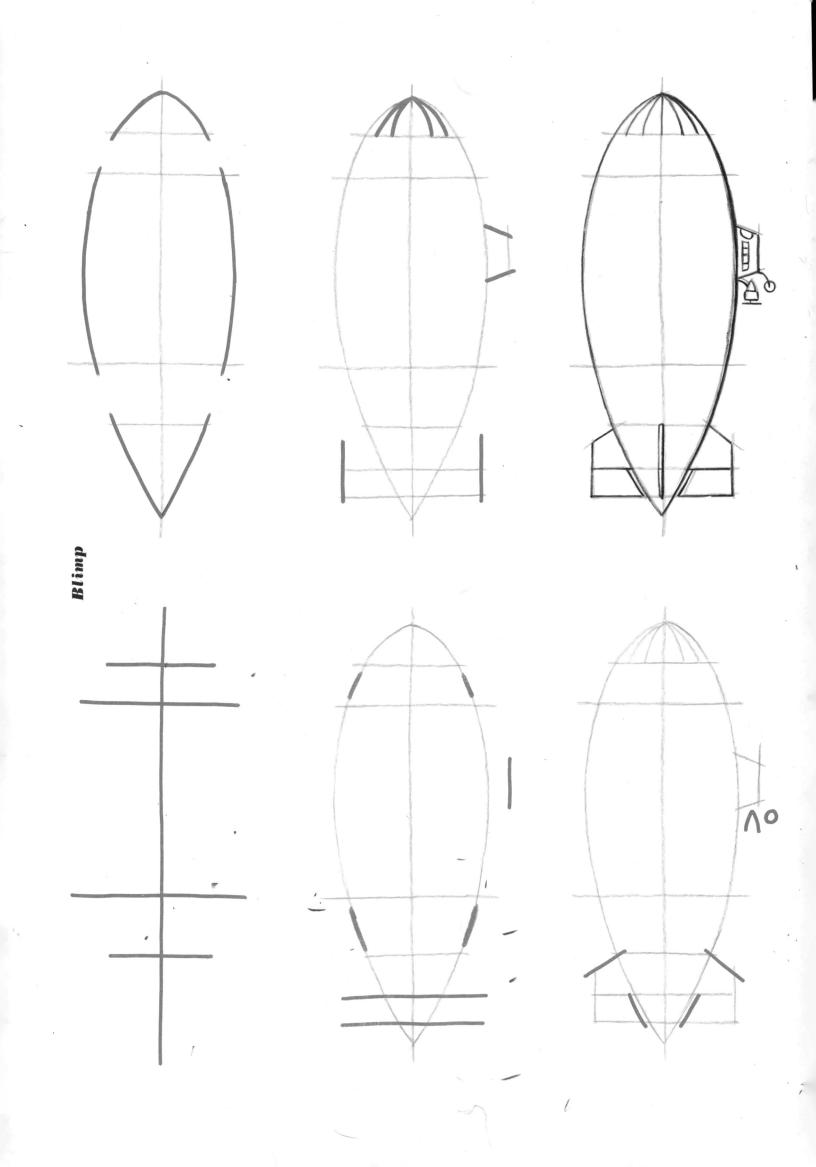

Balloon

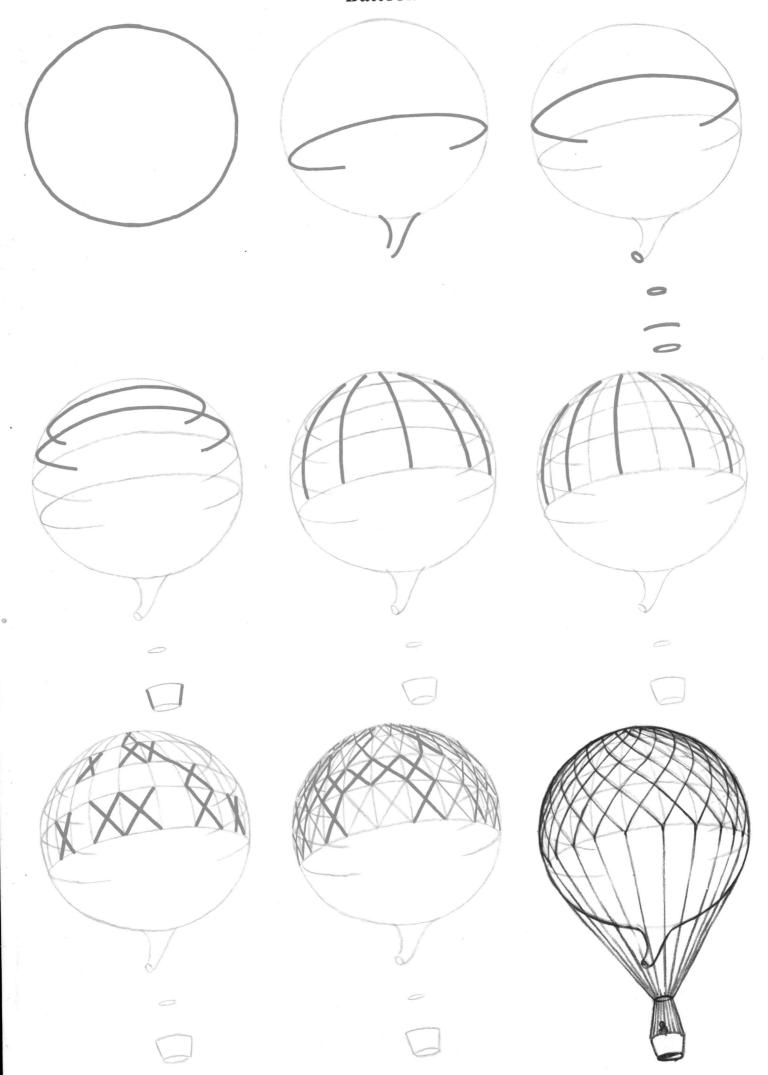

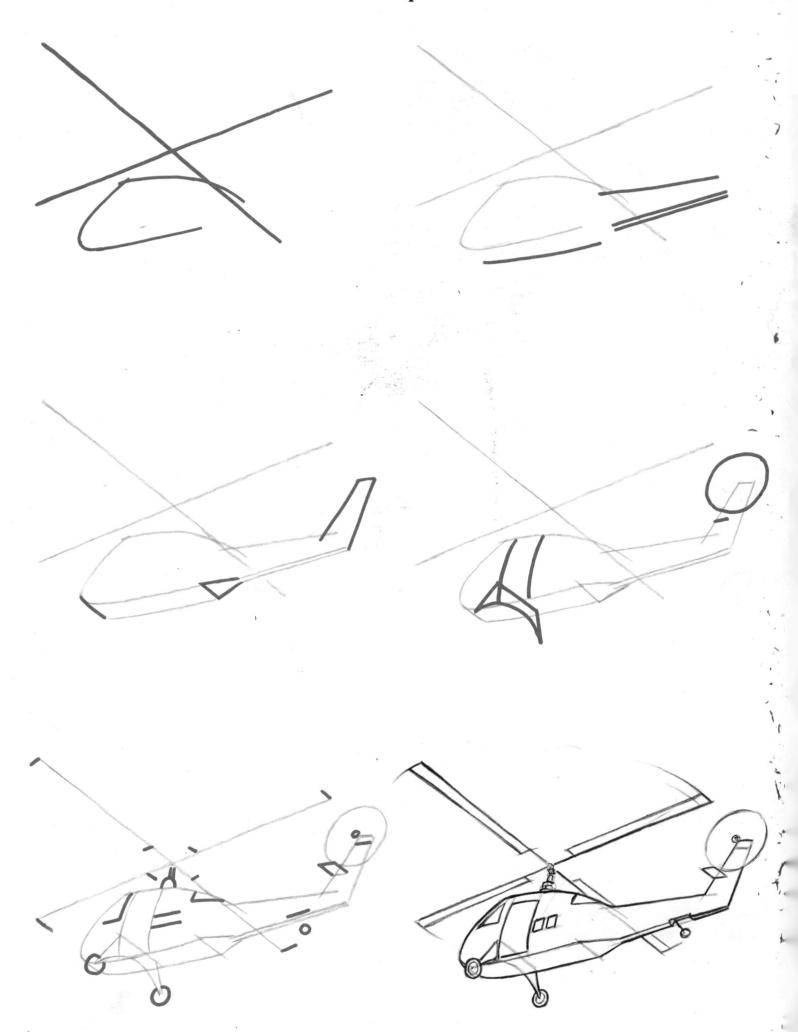

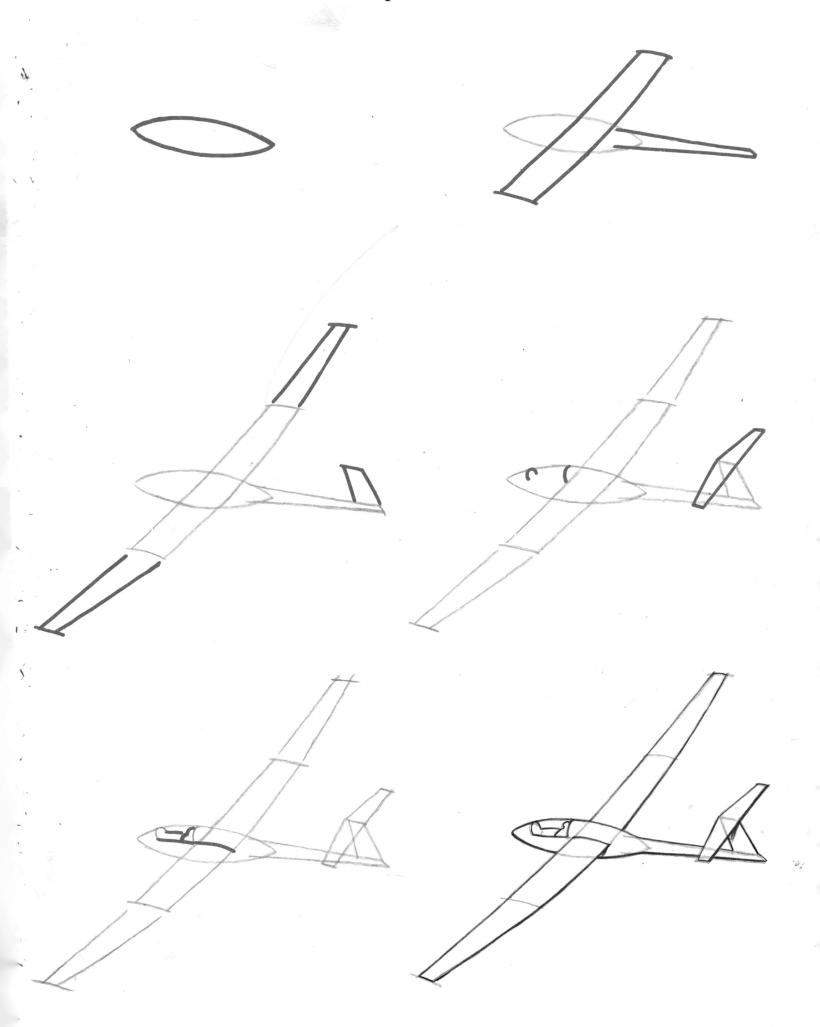

Apollo command module (USA)

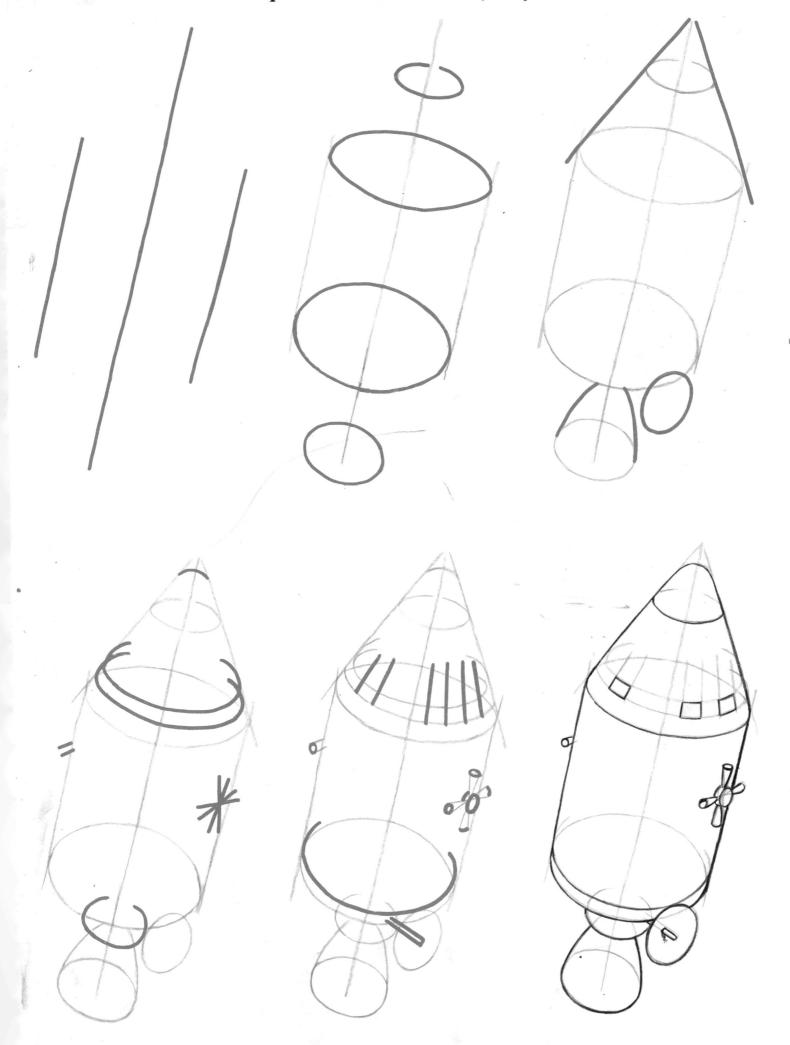

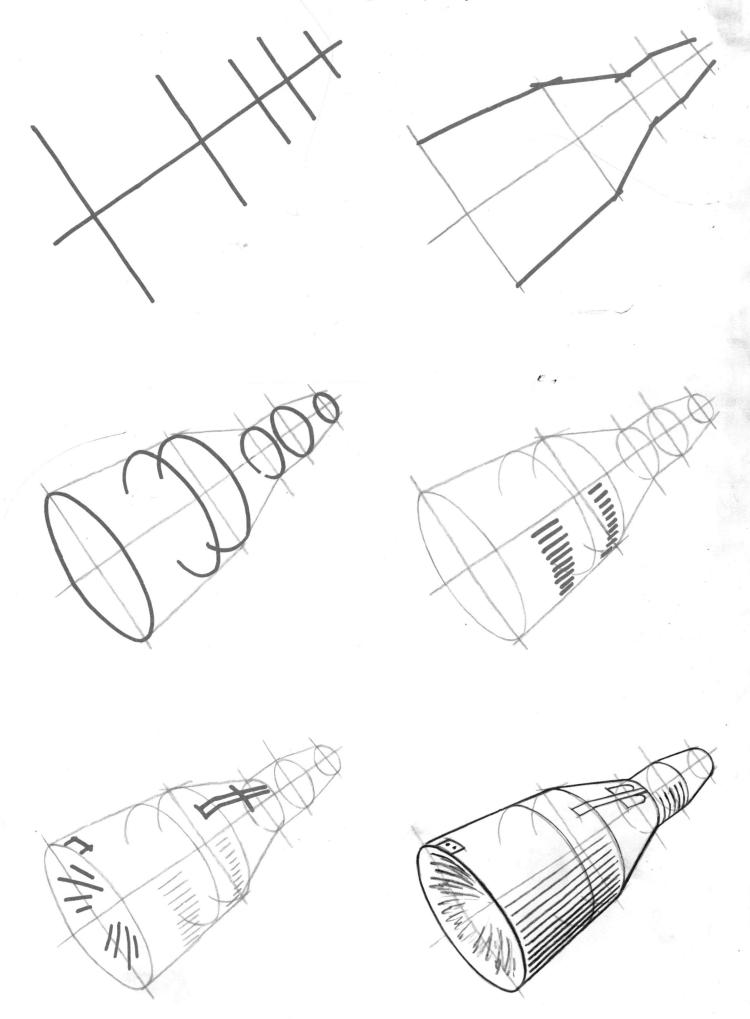

The Wright brothers' first airplane

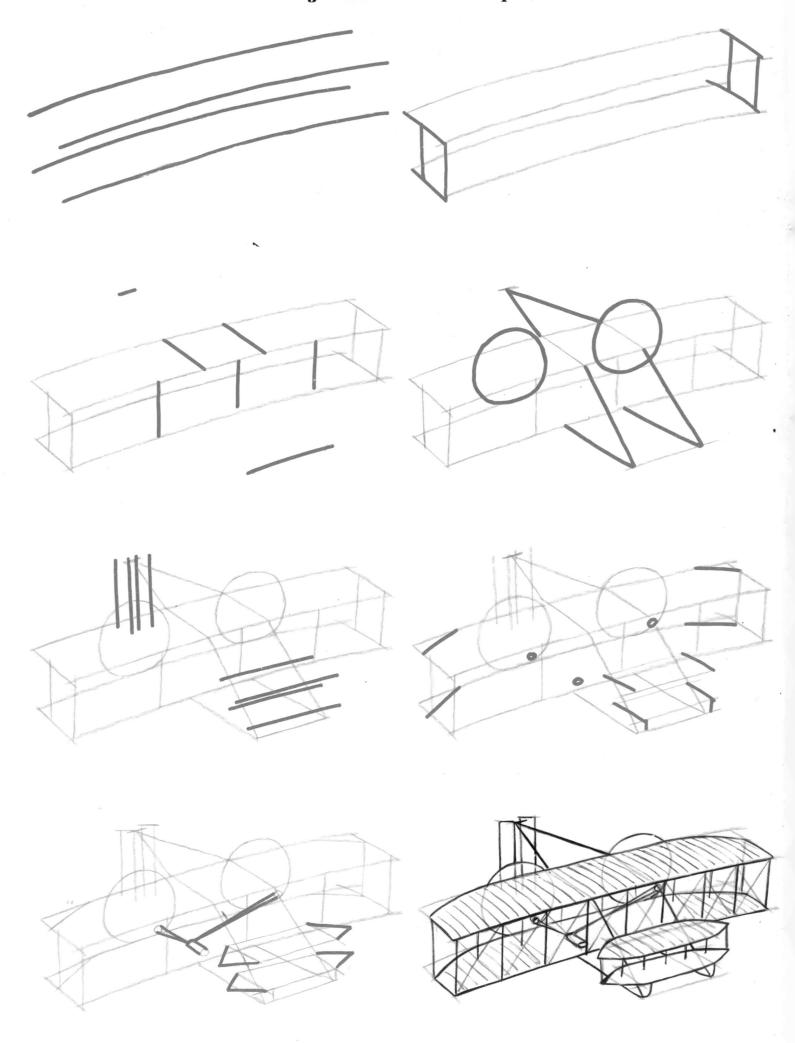

About the Author

LEE J. AMES, a native New Yorker, has been earning his living as an artist for thirty-five years. He started out working on Walt Disney's *Fantasia* and *Pinocchio* in what he himself describes as a minimal capacity. He has also taught at the School of Visual Arts and, more recently, at Dowling College on Long Island. He owned and operated an advertising agency briefly and has illustrated for several magazines. When not working, he enjoys tennis. Mr. Ames has illustrated over one hundred books, from preschool picture books to postgraduate texts, including *Draw 50 Animals, Draw 50 Boats, Ships, Trucks and Trains*, and *Draw 50 Dinosaurs and Other Prehistoric Animals*.